Cloudspotting
for Beginners

Cloudspotting
for Beginners

Gavin Pretor-Pinney
& William Grill

TEN SPEED PRESS

California | New York

Have you ever watched
a cloud being born?

Pick a clear day when just a few white puffs scatter
the blue. Try to spot where the faintest patch of cloud
is beginning to appear. It'll look at first like the very tip
of a cloud is forming.

Gradually, your little white smudge might build into
dazzling, bright mounds. A cloud has been born!

You will soon be able to say which of the ten main types
of cloud yours is. Each type has its own special qualities.
Each has a part of the sky where it likes to hang out.
And each has a fancy Latin name.

So, what will your cloud grow up to be?

The Ten Main Clouds

Cirrus

Cirrostratus

Cirrocumulus

Altostratus

Nimbostratus

Stratocumulus

Stratus

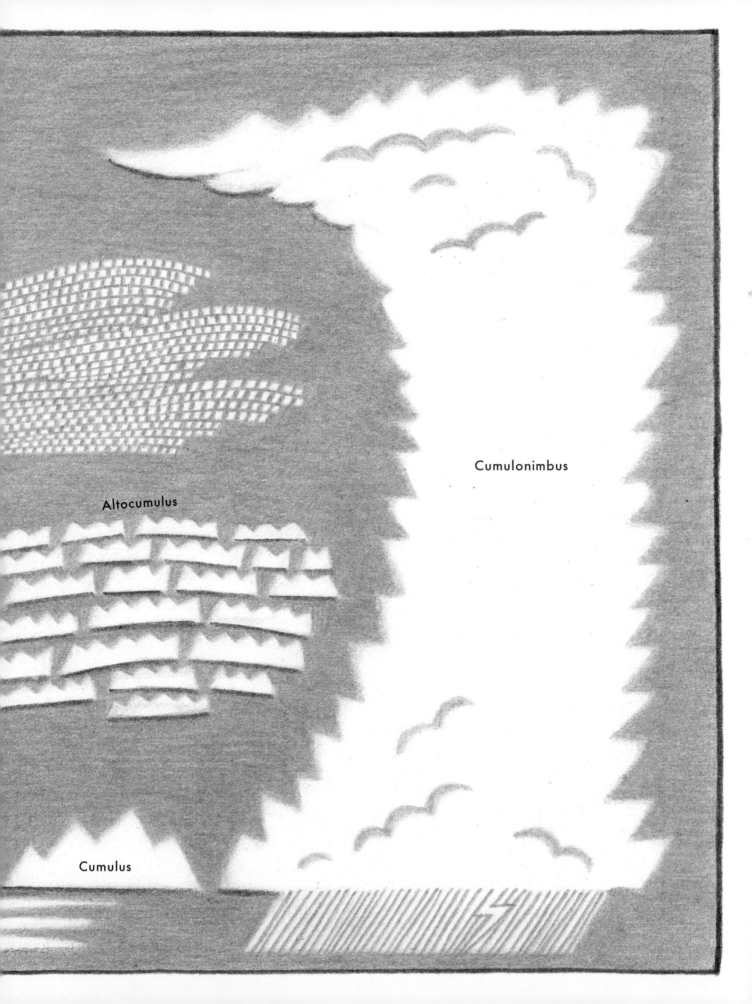

Cumulonimbus

Altocumulus

Cumulus

CUMULUS is a happy-go-lucky cloud. It forms on sunny days, low in the sky, on invisible columns of air rising off the sun-warmed ground. It has crisp edges, a flattish base, and mounds on top like a cauliflower.

Everyone loves a Cumulus.

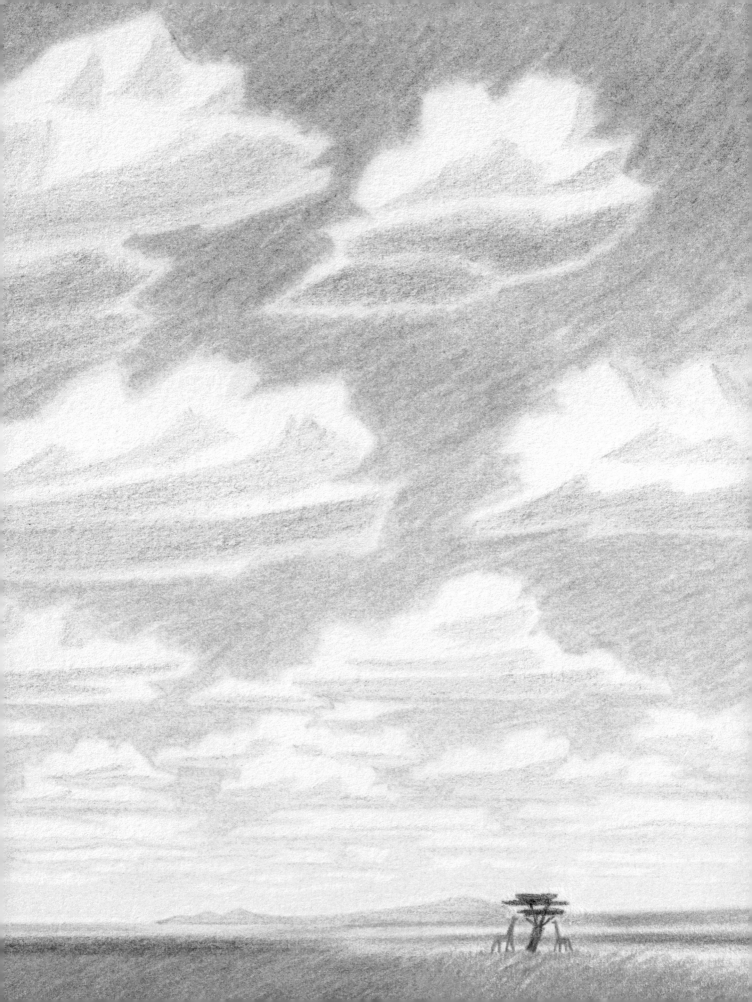

STRATOCUMULUS is the world's most common cloud. That's because it forms over huge areas of ocean. When you see it from land it's a low, clumpy layer that often looks a bit scrappy, like a rough patchwork of white and gray. From the window seat of a plane, it's a landscape for your imagination made of rolling cloud hills and valleys.

STRATUS is a low cloud blanket to fall asleep in.

It's a smooth, light gray layer that often obscures the tops of hills and skyscrapers.

Sometimes it drifts in from the sea.

It's the only cloud that visits us down at ground level, which is when we call it fog.

ALTOCUMULUS is a midlevel cloud: higher than the low ones, and lower than the high ones. It's often arranged in lots of little clumps, known as cloudlets. Altocumulus likes to organize its cloudlets into orderly patterns that can cover the whole sky. It's a cloud that likes to be neat and tidy.

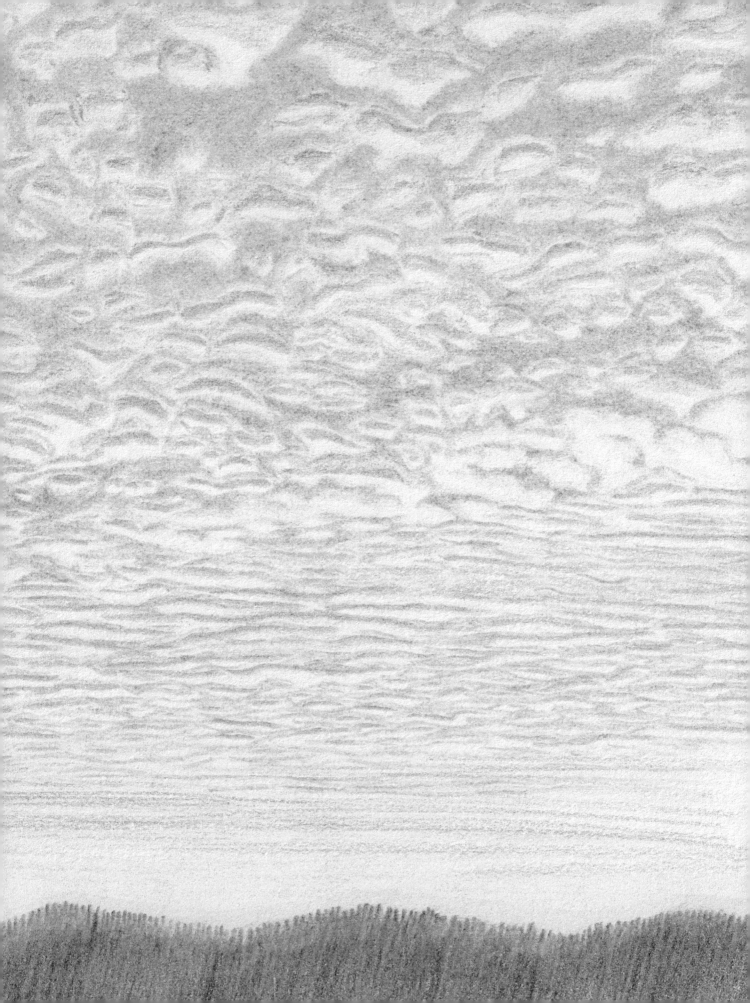

ALTOSTRATUS is a bit of a boring cloud. Sorry if that sounds mean, but its featureless, overcast sky just hangs around, with little to say for itself. The most exciting thing Altostratus ever does is lightly drizzle.

But every cloud has its moment to shine. At sunrise or sunset, this cloudy canvas can be briefly adorned with glorious washes of gold, red, and purple. Then it goes back to being boring again.

CIRRUS is the very loftiest of the ten main clouds.
It lives up where aircraft cruise. Made of ice crystals falling
through the powerful winds of high air, it looks like locks of
wild white hair combed out across hundreds of miles.

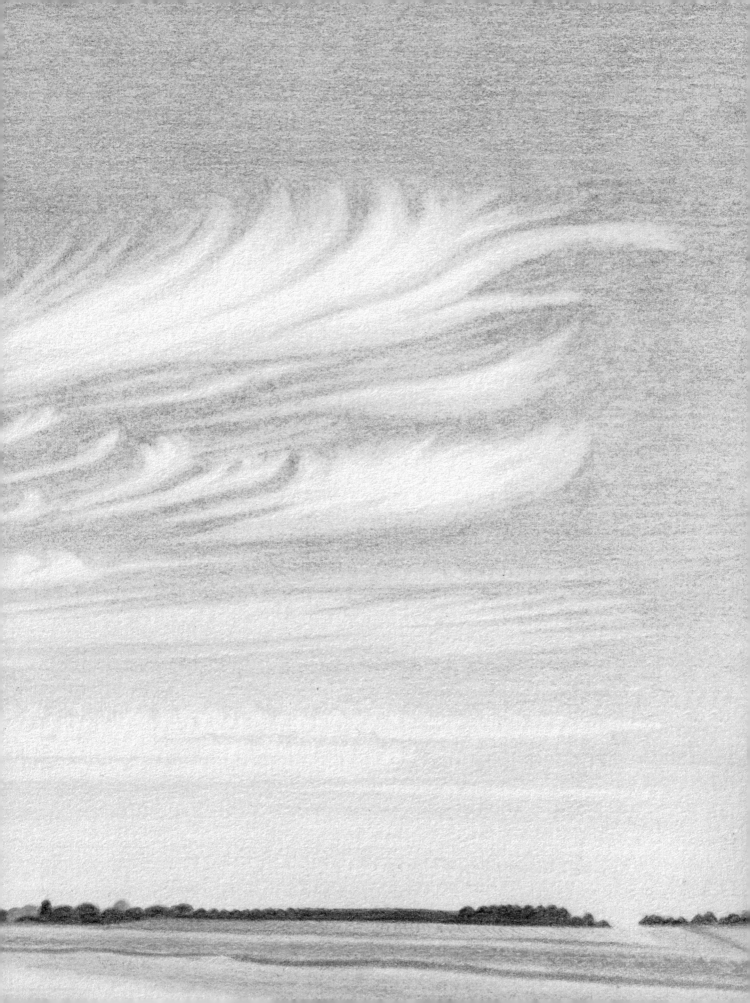

CIRROCUMULUS is the rarest of the ten main clouds. It has cloudlets so small that it looks like sugar sprinkled across the sky.

And it won't remain a Cirrocumulus for long. So cold are its droplets that they soon freeze into the streaks or layers of ice crystals known as Cirrus or Cirrostratus. This is a cloud that doesn't like to hang around.

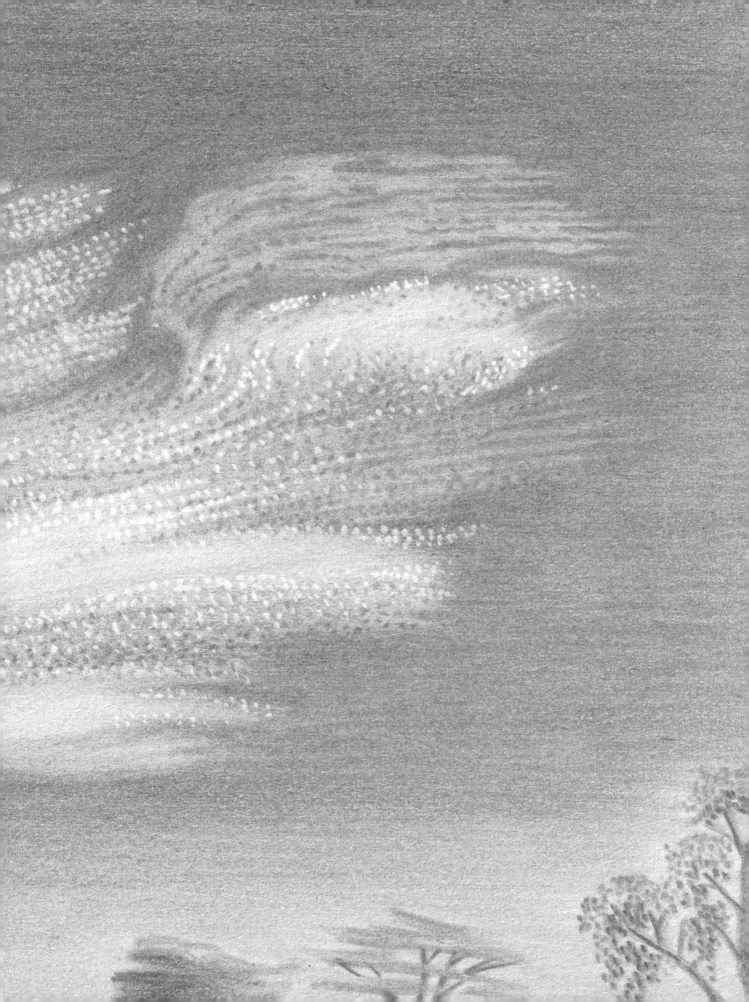

CIRROSTRATUS is quiet, shy, and retiring. And that's fine, because not every cloud needs to be a showstopper. This high layer of ice crystals barely even looks like a cloud – more like just a slight whitening of the blue. Though it doesn't make a fuss, it's as much a cloud as any other. Most people miss a Cirrostratus altogether. But not you, you'll spot it, because you're not most people.

NIMBOSTRATUS is the thick, wet blanket of the sky. Dark and featureless, it rains and rains or snows and snows. For many people, it's the cloud that gives the other clouds a bad name. But if you happen to live somewhere that's bone-dry, Nimbostratus might turn out to be your best friend.

CUMULONIMBUS is the rock star of the cloud world.
Every little cloud who wants to make a splash dreams
of becoming one. This is the tallest of all the clouds
and produces heavy showers, sometimes made of hail,
with thunder and lightning thrown in just to show off.

A Cumulonimbus often spreads out on top like a vast mushroom. From a distance, it looks calm and serene. But don't be fooled. In the pelting showers and howling winds below, this cloud is dark, wild, and angry.

The pharmacist **LUKE HOWARD** loved clouds so much that he came up with a system for naming them. One damp London night in the winter of 1802, in a debate at a science society, he declared that we should give clouds Latin names like "Cumulus," "Cirrus," and "Stratus." We use Latin for plants and animals, he argued – why not clouds?

Howard showed his audience cloud paintings indicating the shapes we can learn to recognize. Of course, clouds constantly change shape, so any name might only work for a cloud at a particular moment before it changes into a different type. His talk was a big success, and word got around that there was a new language for the sky. Soon, scientists, artists, and poets everywhere were using Howard's cloud names, and over time more names were added to the system. You could say that Luke Howard was the godfather of cloudspotting.

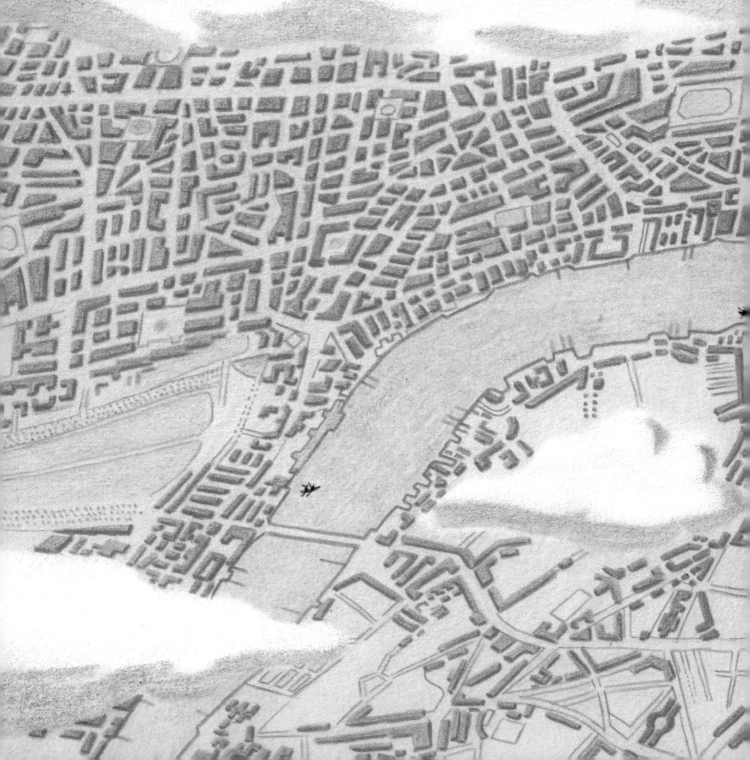

Hold it with all those Latin names. **WHAT IS A CLOUD, ANYWAY?**
Clouds are made of water. Simple as that. OK, not quite as simple as that.

Low clouds like the solid-looking fair-weather
Cumulus are made of water droplets. These are
so tiny, each just one-hundredth of a millimeter
across, that you'd have to put seven of them
side by side just to span the width of a human hair.

HOW HEAVY IS A CUMULUS?

They're not as light as they look. If you added together all the droplets in a medium-
size Cumulus, they'd weigh the same as about eighty elephants. Of course, this water
would fall like a stone if it was all joined up in one clump. But it isn't. Each of a Cumulus
cloud's droplets is tiny and easily wafted by air currents rising up through the cloud.
A cloud stays up because it's not one big thing but a group of tiny, tiny things.

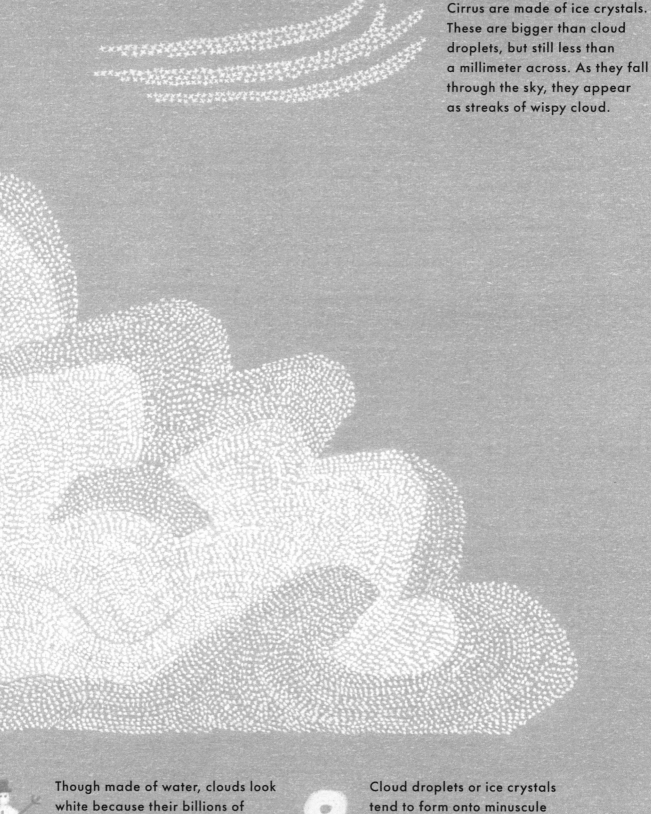

High clouds like the sweeping Cirrus are made of ice crystals. These are bigger than cloud droplets, but still less than a millimeter across. As they fall through the sky, they appear as streaks of wispy cloud.

Though made of water, clouds look white because their billions of droplets or ice crystals reflect the light every which way, and this scattering of light looks white to us. Snow looks white for the same reason.

Cloud droplets or ice crystals tend to form onto minuscule specks like dust floating in the air. They are too small to see, but they're an essential ingredient in the making of a cloud.

Ice crystals in the sky are as varied as the clouds themselves, but most have one thing in common: **THE NUMBER SIX**.

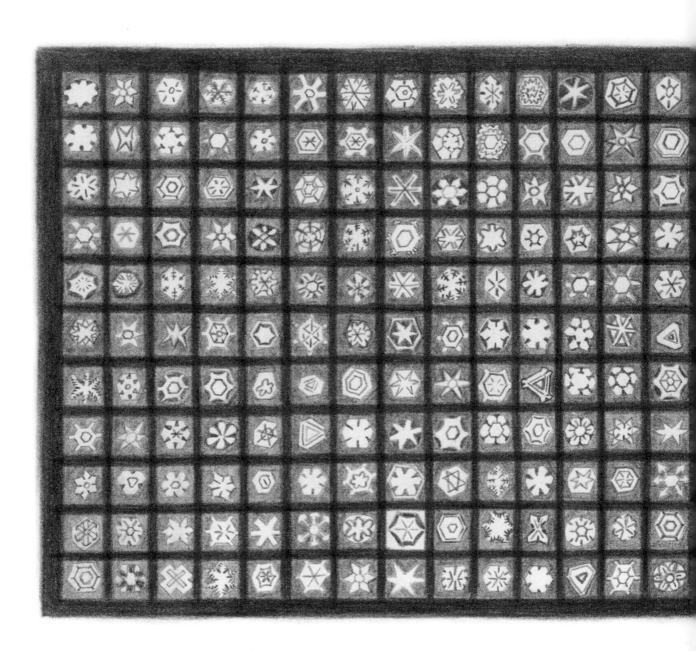

WILSON BENTLEY was given a microscope for his fifteenth birthday in 1880. When he used it to examine the tiny ice crystals in the snow that covered his family's Vermont farm, he was amazed by how different they were, and how beautiful.

When they grow in a cloud, ice crystals have six-sided shapes. Sometimes, they have six branches with tiny delicate spikes on them. Sometimes, they're six-sided plates or columns, rather like unsharpened pencils. It's just how the smallest bits of water, known as water molecules, most easily fit together to make ice.

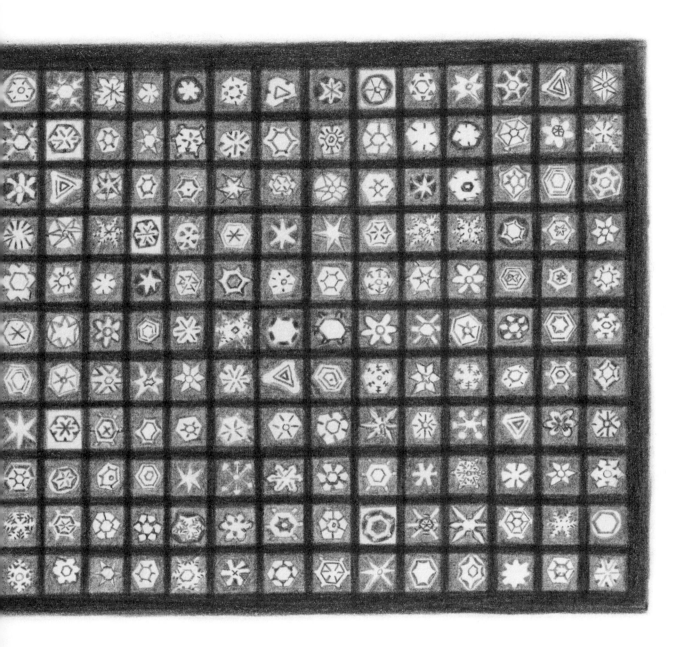

Aged nineteen, Wilson bought a camera – a great cumbersome thing with bellows, glass photo plates, and a tripod. He then worked out how to take pictures down the microscope, and how to catch the ice crystals as they fell on a piece of chilled velvet, transferring them to chilled glass slides with a turkey feather. "Snowflake Bentley" went on to take more than five thousand ice crystal photographs during his lifetime.

The taller a cloud grows, the more likely it is to make **RAIN, SNOW, OR HAIL.**

That's because a tall cloud is colder at the top, so its droplets up there are more likely to freeze, and when they freeze they start to fall. Often they melt again as they pass through warmer air below, changing from ice back into liquid and landing as raindrops. They can't make up their minds what they want to be, those little drops of water.

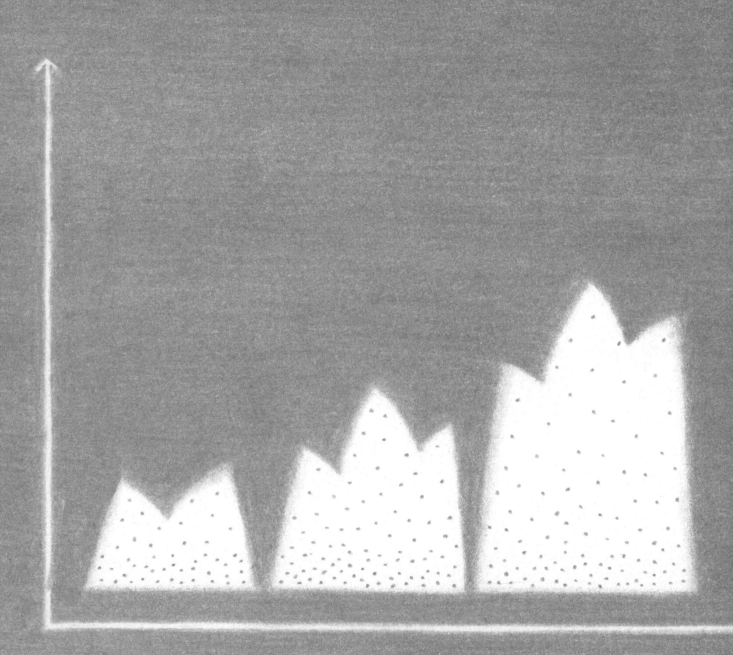

As the cloud grows taller, some of the droplets up in its chilly summit start to freeze. Those ice crystals hold on to water molecules tighter than their neighboring droplets do, and so the crystals grow as the droplets shrink. Soon, lots of tiny, light droplets have changed into fewer, larger ice crystals that are heavy enough to fall.

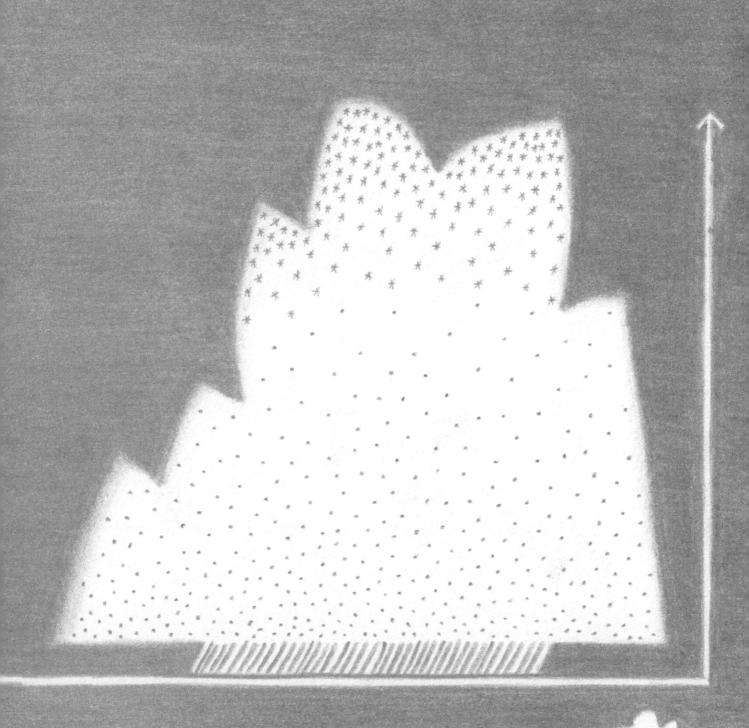

Sometimes, if the air below is warm and dry enough, ice crystals falling from a cloud can evaporate away before ever reaching the ground. From a distance, they look like wavy trails hanging from the cloud. Known as **VIRGA** or **FALLSTREAKS**, they're the jellyfish of the sky.

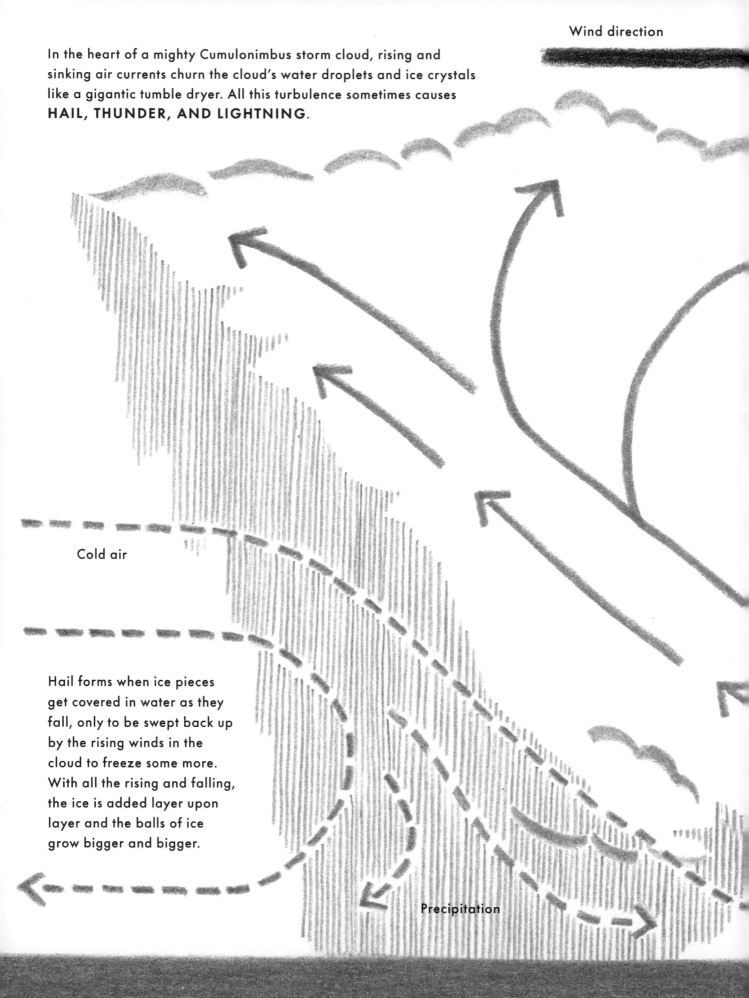

In the heart of a mighty Cumulonimbus storm cloud, rising and sinking air currents churn the cloud's water droplets and ice crystals like a gigantic tumble dryer. All this turbulence sometimes causes **HAIL, THUNDER, AND LIGHTNING**.

Cold air

Hail forms when ice pieces get covered in water as they fall, only to be swept back up by the rising winds in the cloud to freeze some more. With all the rising and falling, the ice is added layer upon layer and the balls of ice grow bigger and bigger.

Precipitation

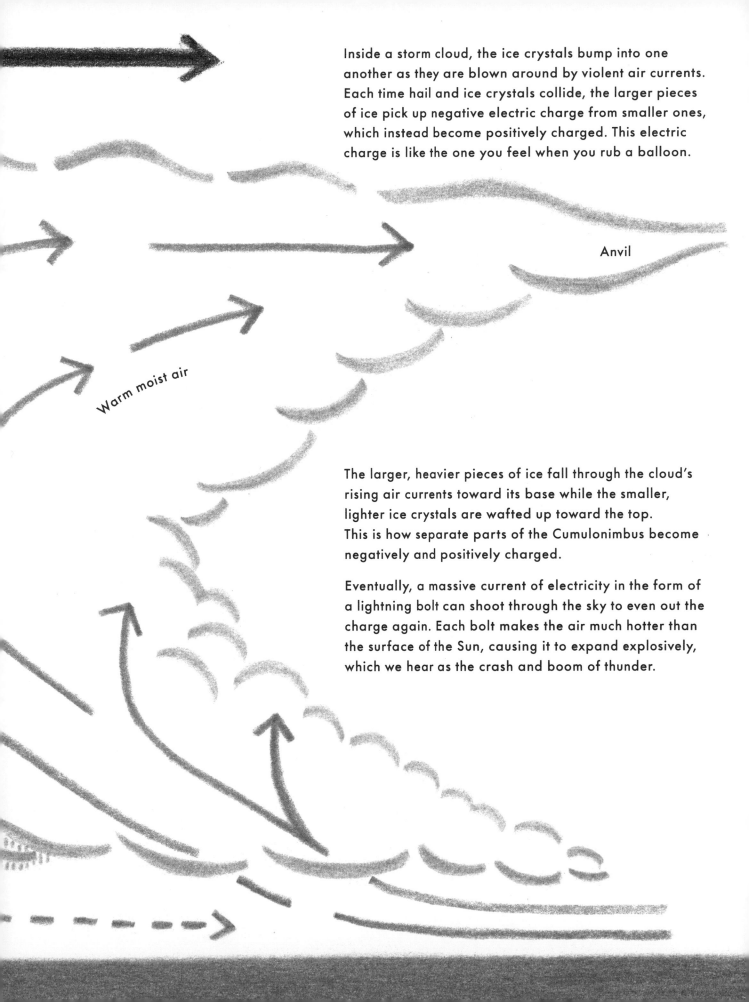

Inside a storm cloud, the ice crystals bump into one another as they are blown around by violent air currents. Each time hail and ice crystals collide, the larger pieces of ice pick up negative electric charge from smaller ones, which instead become positively charged. This electric charge is like the one you feel when you rub a balloon.

Anvil

Warm moist air

The larger, heavier pieces of ice fall through the cloud's rising air currents toward its base while the smaller, lighter ice crystals are wafted up toward the top. This is how separate parts of the Cumulonimbus become negatively and positively charged.

Eventually, a massive current of electricity in the form of a lightning bolt can shoot through the sky to even out the charge again. Each bolt makes the air much hotter than the surface of the Sun, causing it to expand explosively, which we hear as the crash and boom of thunder.

As it grows, your cloud will likely make some patterns or shapes along the way — like this **RADIATUS**, a cloud that seems to fan out from a distant point.

This is how a cloud **STANDS OUT FROM THE CROWD.**

The Special Clouds

Cavum

Contrail

Fibratus

Horsehoe vortex

Virga

Arcus

Murus

Tornado

Volutus

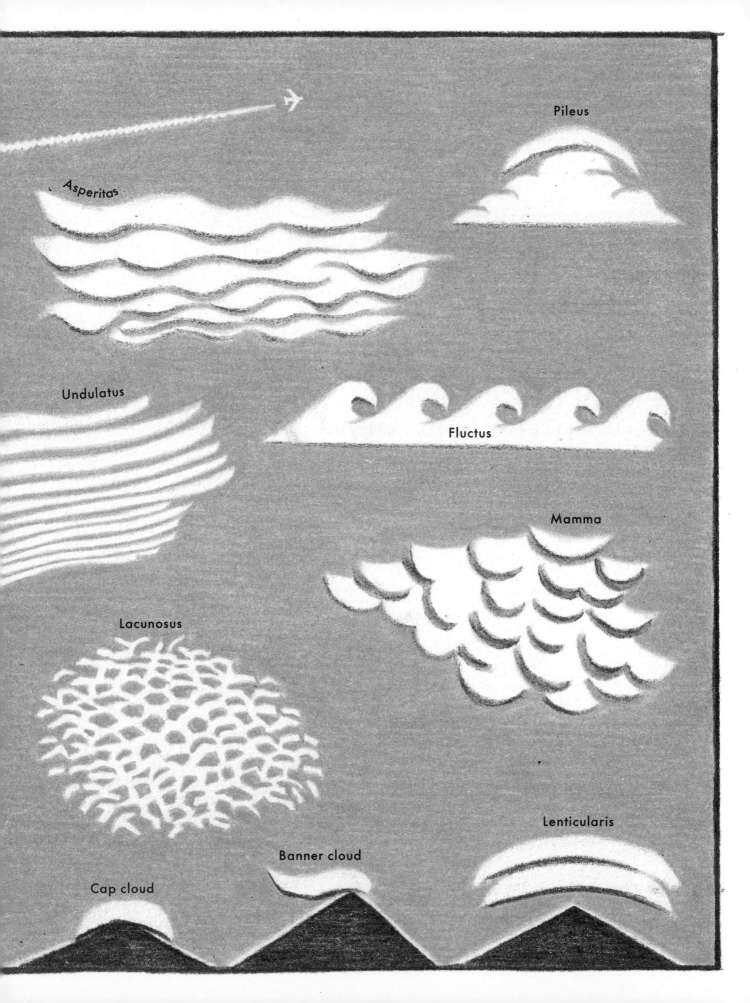

Sometimes, a cloud like this Altocumulus
is arranged in row upon row, like ocean waves
rolling onto the shore.

This cloud pattern is known as **UNDULATUS**,
and it's just one of many ways that waves
can appear in the sky.

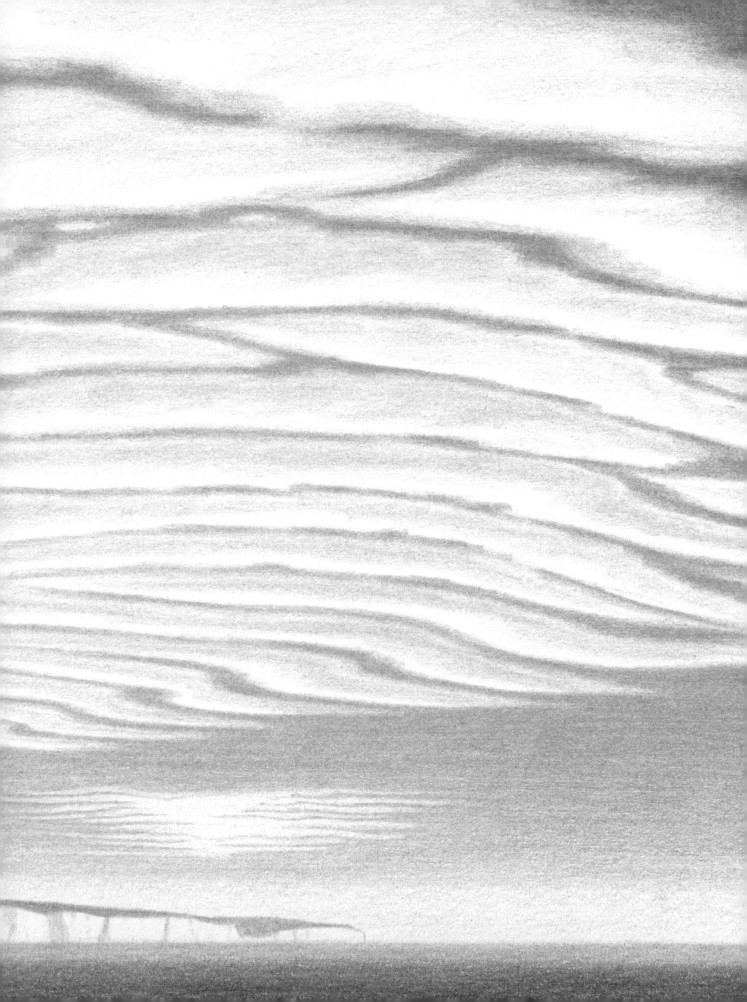

You can think of the earth's atmosphere as an **OCEAN OF AIR**.

Although it's made of gases, not saltwater, the atmosphere still has waves rolling through it. They're mostly invisible – unless a helpful cloud is nearby to reveal them.

This is the **ASPERITAS** cloud pattern. Its distinctive choppy waves were first spotted by members of the Cloud Appreciation Society, who argued that it should have an official name. The World Meteorological Organization agreed, and so, in 2017, asperitas became the first new cloud name in fifty-four years.

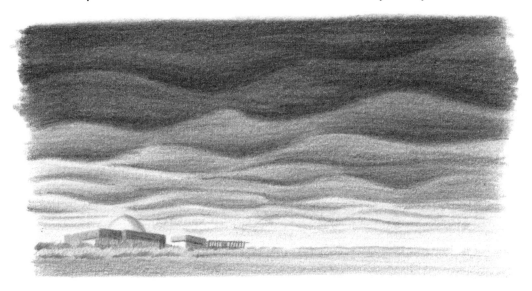

Occasionally, the tops of clouds curve over to look like ocean breakers. Known as **FLUCTUS**, these curling shapes form when the wind above the cloud blows much faster than the wind below it. They are rare, fleeting clouds. If you want to spot one, you'd better pay attention. Fluctus only appear for two or three minutes before their wave shapes break up in the wind.

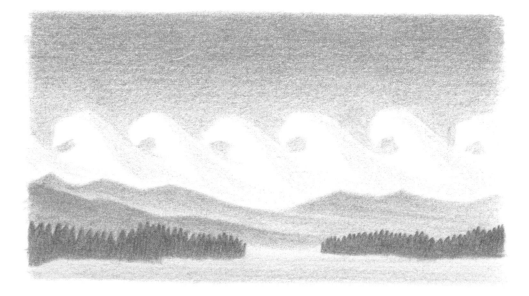

A huge **ROLL CLOUD** often appears in springtime off the coast of Queensland, Australia – it's such a regular visitor that locals have given it their own name: the Morning Glory.

Surfing the Morning Glory is cloudspotting for thrill-seekers.

But wait, what's a roll cloud? It's officially known as **VOLUTUS**, and it looks like a long tube of cloud, often low in the sky, stretching from horizon to horizon. It forms in the middle of an invisible wave of air that can travel as fast as a champion sprinter. This wave of air is lifting at the front of the cloud, and sinking at the back. Glider pilots travel thousands of miles to ride this mighty volutus, like regular surfers on an ocean wave.

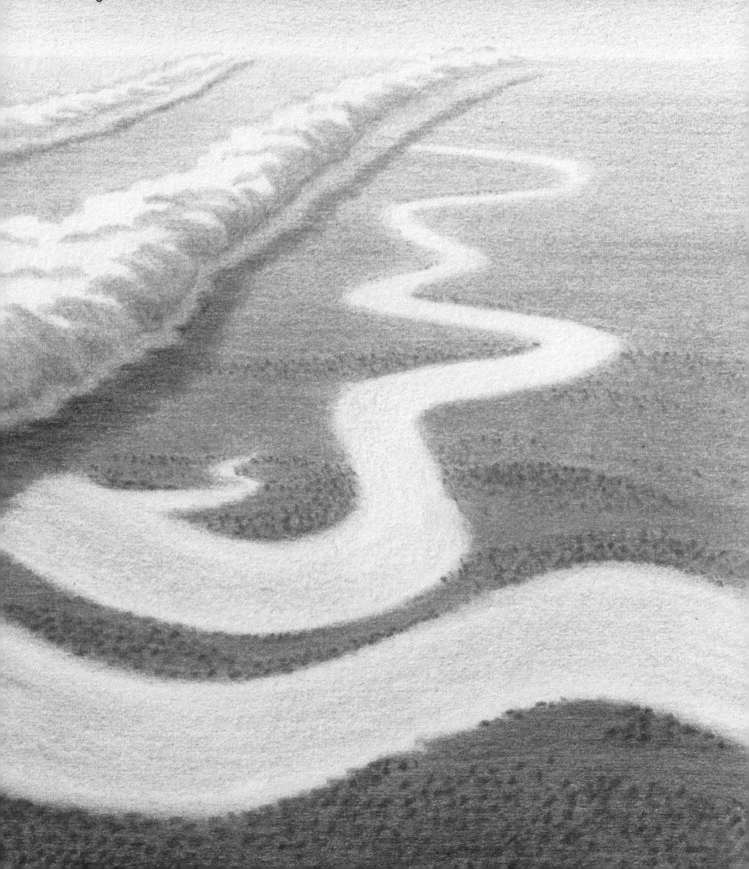

CLOUDS LOVE MOUNTAINS, and mountains love them back. They couldn't be more different from each other, but they often hang out together. The clouds form when air cools as winds rise to flow over mountain peaks.

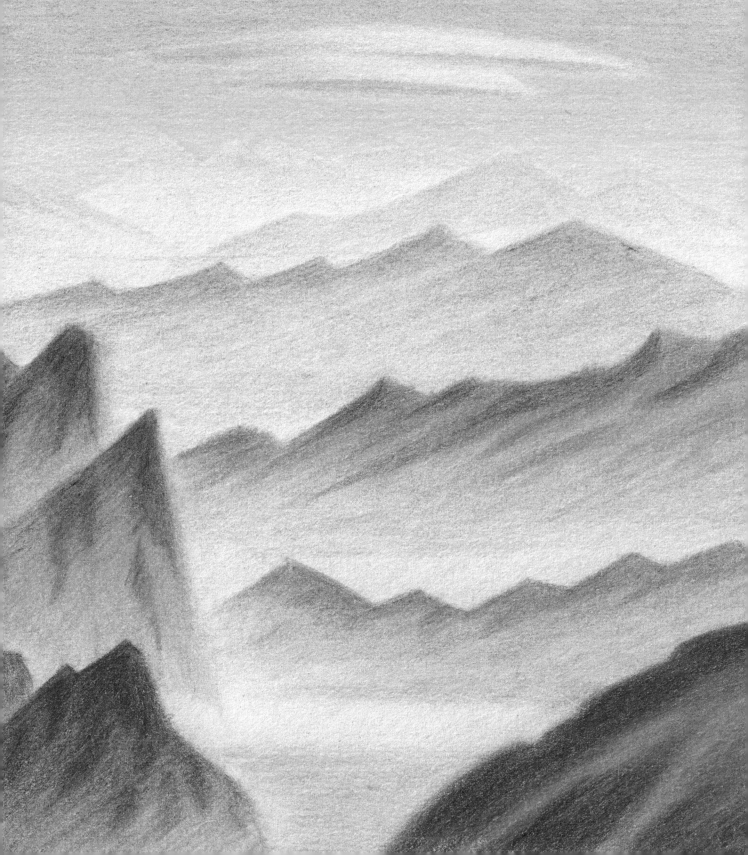

LENTICULARIS clouds hover near mountains and hills. They look like flying saucers because they're often shaped like discs. Weirdly – almost magically – even when the winds are strong, lenticularis remain in the same position.

While the cloud droplets are swept along in the wind, they all form and evaporate away again at the same places, so the cloud appears to hover in the sky. What else would you expect from a flying-saucer cloud?

Clouds that form as winds flow over hills or mountains sometimes hang out at the summits, but not always. They can form many miles downwind of the peaks that create them, or they can gather in the valleys below.

A CAP CLOUD looks like a smooth hat perched on the mountain's head, and often hides the peak from view.

A BANNER CLOUD appears attached to a mountaintop. It forms in strong winds behind sharp summits, fluttering like a huge, slow-motion flag.

STACKED LENTICULARIS clouds are when discs of cloud appear one on top of the other like a pile of pancakes. When you see them first thing in the morning, the cloud pancakes are drenched in the honeyed light of sunrise.

VALLEY FOG forms on clear nights, especially after rain, as the air cools and sinks down mountain slopes to gather in the valleys below.

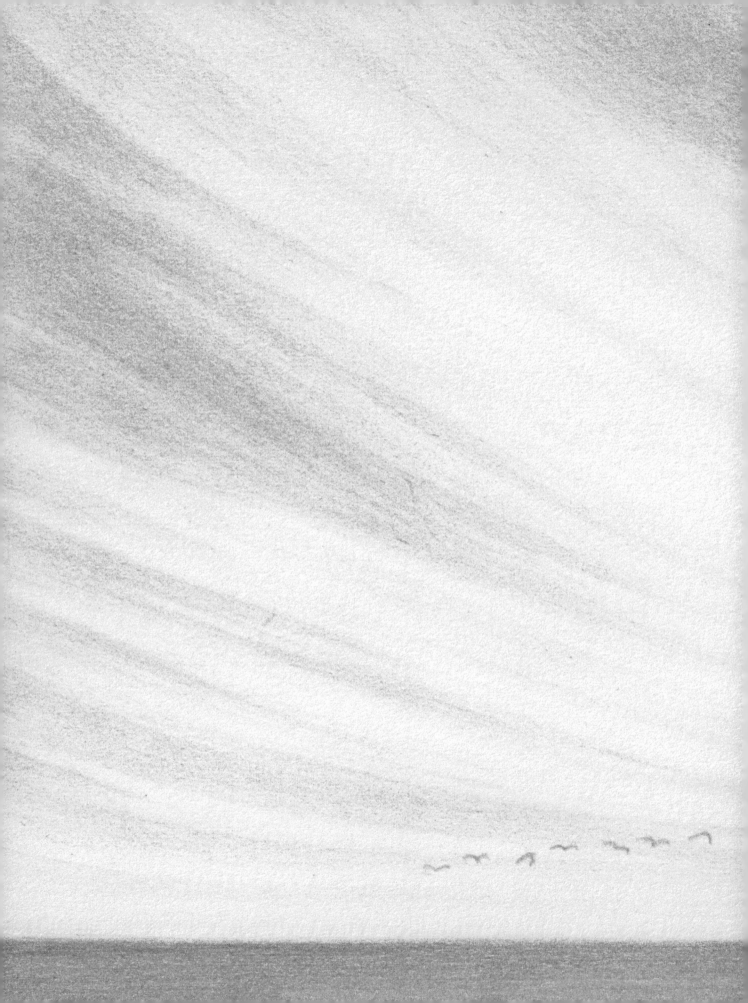

Clouds can form long streaks across the sky.
This happens when the ice crystals in high clouds
like Cirrus and Cirrostratus fall through winds
that become gradually slower.

The pattern is known as **FIBRATUS**, and it looks
like the cloud has been combed by the wind,
all neat and smart, and ready to face the world.

CONTRAILS are human-made clouds. They're the long lines that form behind high-flying aircraft.

The water vapor in a jet engine's hot exhaust cools in the air behind the aircraft, condensing into droplets of cloud. When the surrounding air is cold and damp enough, the droplets hang around as a trail of cloud. Some days, they freeze and spread out sideways as a broad strip of ice crystals, forming a criss-cross pattern. Other days, they don't form at all because the air is too heavy. There were no contrails before we flew planes. And there won't be any in the future if we can learn to fly without burning fuel.

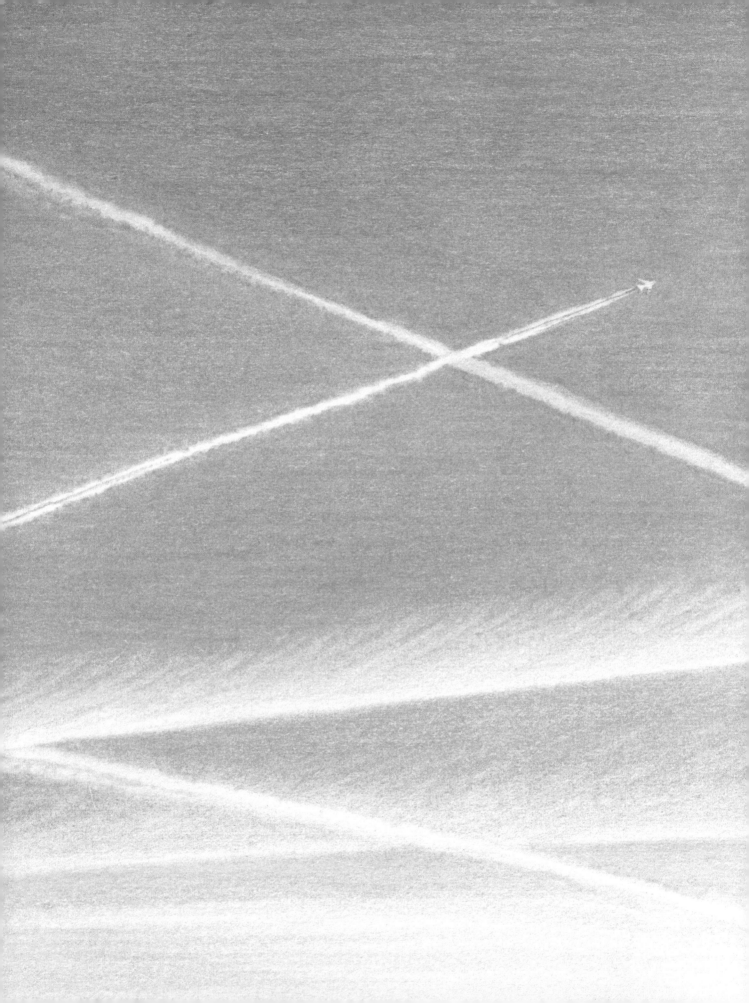

Cool air above a cloud can sink down in pockets to make a pattern of holes called **LACUNOSUS**. The holes are where the cold air is sinking, and the edges of cloud around them are where the warmer air is rising up to replace it. These clouds are the honeycombs of the sky. Yum!

CAVUM is a large hole that appears in a layer of cloud when the droplets there start freezing and falling below as ice crystals. Once the freezing starts, it spreads outward. Over thirty minutes or so, the hole just gets bigger and bigger – a bit like a hole in the elbow of an old woolen sweater. Sometimes streaks of ice crystals appear trailing down from the hole. They must be the strands of unraveling wool.

Since Cumulonimbus clouds are the rock stars of the cloud world, they tend to go around with a whole bunch of hangers-on.

An **ARCUS**, for instance, is the front bumper of a storm, a low roll sticking out in front as the storm heads your way. When you see the long, low ridge of the arcus cloud, head for shelter!

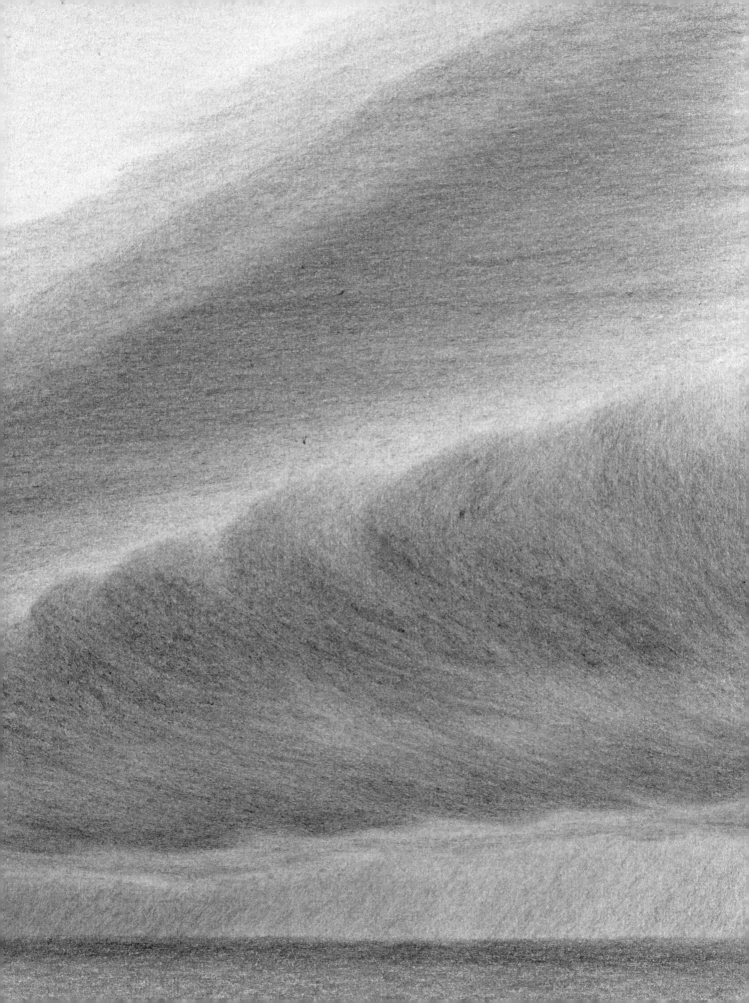

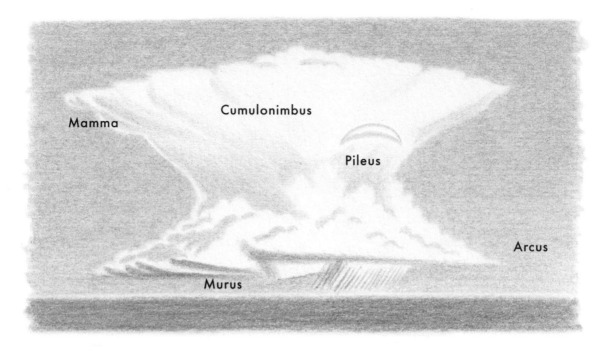

If you want to get to know the crew that hang around with mighty
Cumulonimbus, you first need to know where to look for them.
Each has its own special place.

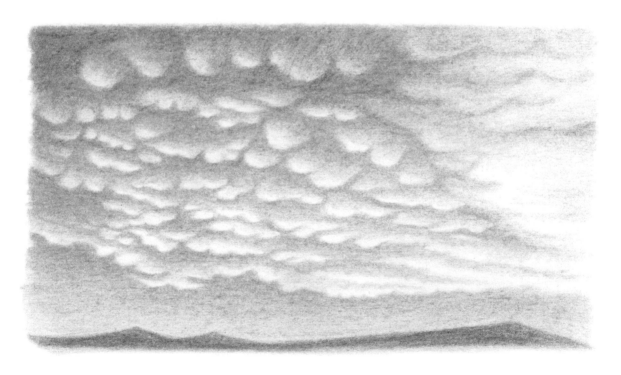

MAMMA are cloud pouches that hang from the underside
of a cloud layer. The most dramatic mamma appear beneath
the spreading tops of huge and powerful storm clouds.

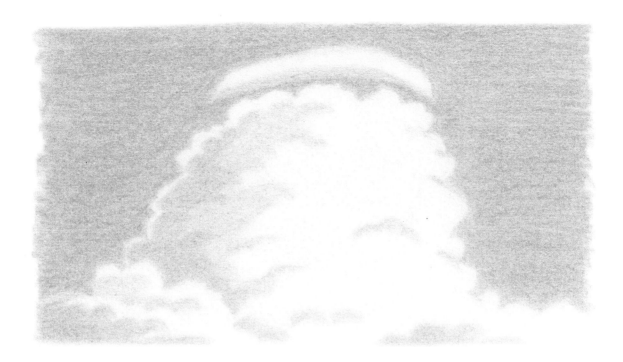

PILEUS is a smooth cap of cloud that appears for a few minutes over the top of a storm as it builds up through the sky. In no time, as it rises, the storm will swallow up its cloud hat.

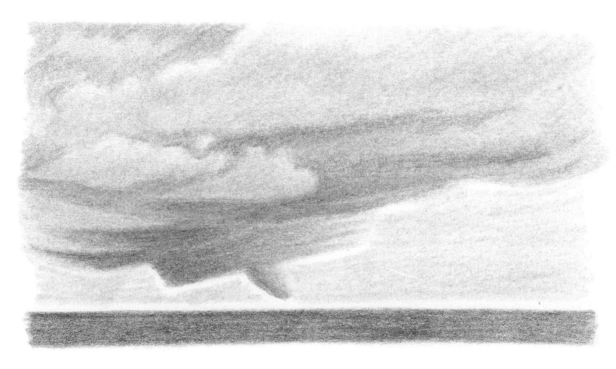

A MURUS, or wall cloud, is a wide column that sticks down from the storm's dark base. It shows where air is being sucked up into the storm, and it's where tornadoes are born.

The air rushing into a Cumulonimbus can start to twist into a **TORNADO**.
Faster and faster it spins, like bathwater swirling down the plughole. Except
that it spins upward, and it's air, not water, and it can tear the roof off a house.
Some forms of tornado suck water, dust, or debris up to meet the cloud.

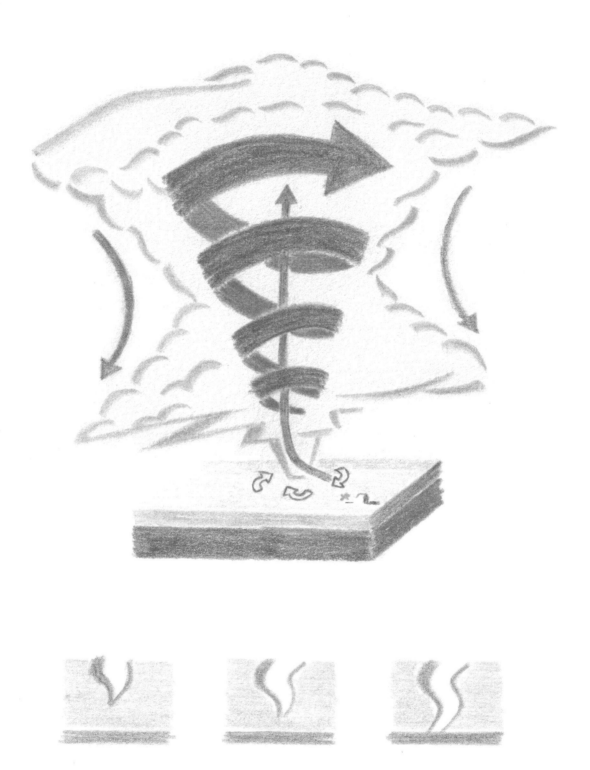

A TUBA is the first sign of a tornado. It looks like a twisting
funnel reaching downward from the storm's base.

A whole range of cloud shapes can form in spinning air, from gentle swirls, to lethal tornadoes.

Horseshoe vortex

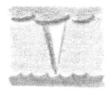

Waterspout

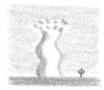

Dust devil

Rope

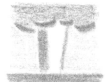

Needle

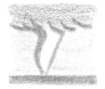

Wire

V-shaped

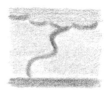

Cigar

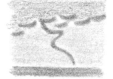

Cylinder

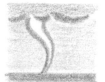

Cone

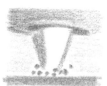

Landspout

Concave

Straight-sided

Convex

Segmented

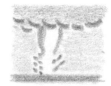

Truncated cone

Bulb-shaped

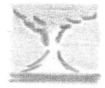

Hourglass

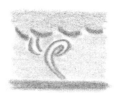

Loop / Ring / Knot

Your cloud must be having fun! But wait till it starts playing with the sunlight.
Once its droplets, ice crystals, or rain showers begin bouncing and bending the
rings, spots, and arcs, or perhaps it will flaunt wavy bands of colorful **CLOUD IRIDESCENCE.**

Welcome to the sparkling, multicolored world of **RAINBOWS, HALOS, AND LIGHT SHOWS.**

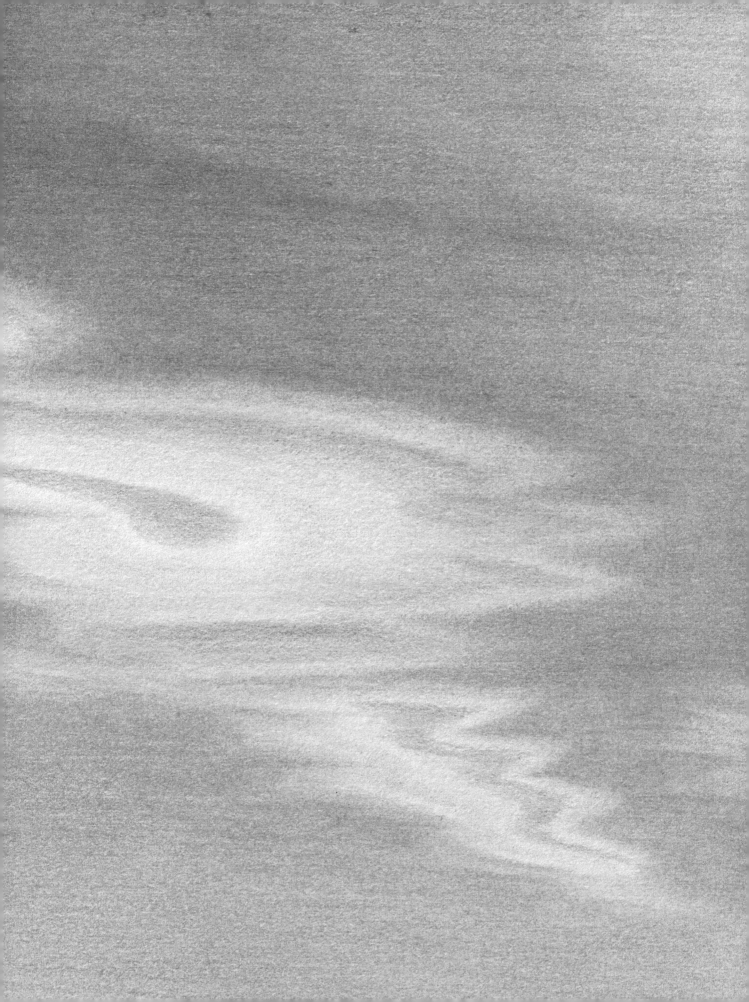

Rainbows, Halos, and Light Shows

Circumzenithal arc

Upper tangent arc

Supralateral arc

Sun dog

Sun

Corona

Sun dog

22-degree halo

Circumhorizon arc

Crepuscular rays

Rainbow

Glory

Reflection bow

Supernumerary bows

Secondary rainbow

Primary rainbow

Fogbow

Low rainbow

Everyone knows about **RAINBOWS**. They're the most famous of all the cloud optical effects. If you've never seen one, where have you been hiding?

The arc of colors appears when direct sunlight shines from behind you onto a rain shower up ahead. The light passes through the falling raindrops and reflects off their inside back surfaces, separating into colors as it goes into and out of the water.

A secondary rainbow appears outside the main one when light bounces off two places at the back of the raindrops.

A fogbow formed by light shining on tiny droplets in fog can look completely white. It's the ghost of a rainbow.

A low rainbow appears when the Sun behind you is high, so just the top of the bow appears aboveground.

Supernumerary bows are tiny lines along the inner edge of the main bow that appear when raindrops are small.

A reflection bow looks at a wonky angle and forms when the sunlight reflects up from still water onto a shower.

A glory looks like rings of rainbow colors around your shadow when it falls onto cloud or fog below you.

Some clouds form colors as the sunlight or moonlight shines through them. The delicate pastel shades are known as cloud iridescence and form when the droplets are really tiny and all of a similar size. You can sometimes see these colors where light shines through the thinning edge of a cloud.

When the iridescent colors form a ring around the Sun or Moon, they're known as a **CORONA.** Be careful spotting iridescence and coronas because dazzling sunlight can damage your eyes as it shines through thin clouds. Never look directly at the Sun – even when there's beautiful cloud iridescence.

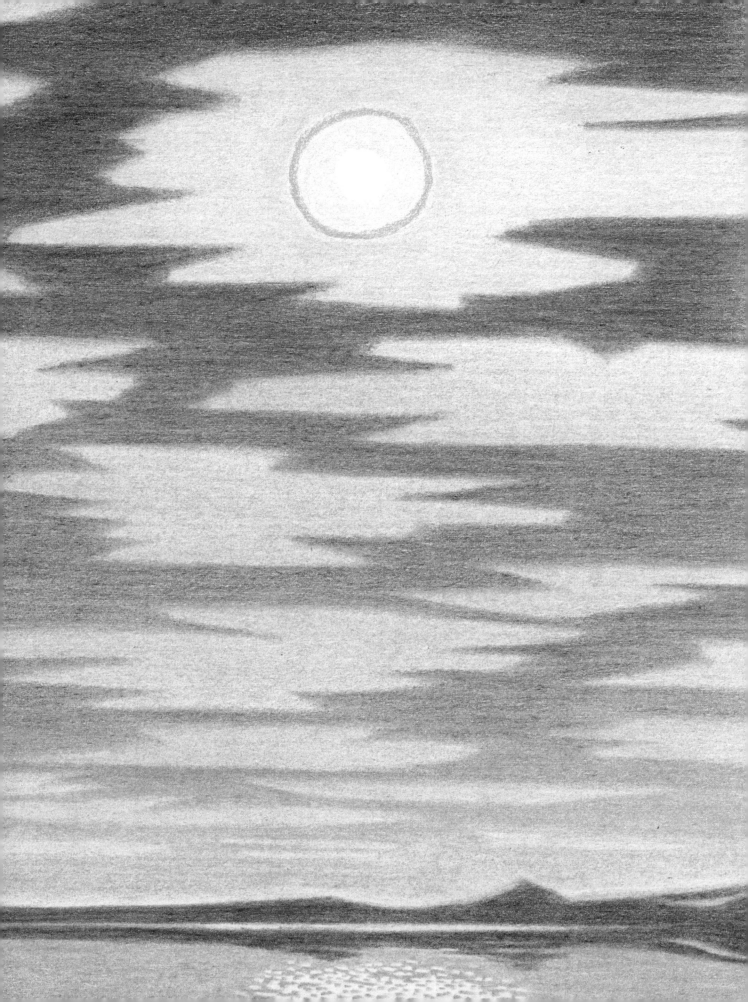

The ice crystals in high clouds can make rings of color too. When the crystals have formed into simple shapes like six-sided plates or columns and they're as clear as glass, the tiny crystals can bend and split the sunlight to form bright rings, spots, and arcs known as **HALO PHENOMENA.**

The easiest to spot is the **22-DEGREE HALO.** It's a perfect circle of light, like a Hula-Hoop in the sky that is centered on the Sun or Moon as it shines through ice crystals like those in the high clouds Cirrus and Cirrostratus.

When ice crystals in the sky are particularly pure and regular in shape, a whole host of halo phenomena can appear. To see the very best displays, you need to go to either the North or South Pole – either that, or near a ski slope, because the pure ice crystals made by snow machines form great optical effects too.

Circumzenithal arc

Supralateral arc

Upper tangent arc

22-degree halo

Sun pillar

Sun dog

Parhelic circle

Sun dog

A CIRCUMZENITHAL ARC is like a smile in the sky. It appears way up above when the Sun is low, which is why most people have never seen one. Only cloudspotters would ever think to look directly upward.

SUN DOGS are bright spots of light to one or the other side of the Sun when it's low in the sky. They sometimes appear with a 22-degree halo. And if you see a sun dog, always check directly upward. A circumzenithal arc might be hiding up there too.

A CIRCUMHORIZON ARC is a flat band of colors appearing way below the Sun, near the horizon. Since the Sun has to be very high in the sky to form it, the effect can only appear, for many parts of the world, in the middle of the day around midsummer.

Clouds change color at **THE START AND END OF THE DAY**. When the Sun shines from near the horizon, its light makes a long journey through the low, dense air. Along the way, the shorter, blue-looking wavelengths of light are filtered out by the gases and dust particles of the air, while the longer, red- and orange-looking wavelengths shine through to paint the clouds in warm, golden colors.

The sky looks blue during **THE MIDDLE OF THE DAY**. In the directions away from the Sun, the light has been scattered toward you by the gases and particles in our atmosphere. Since they scatter more of the shorter wavelengths of light that look blue to us, that's the color we see.

When they want to really show off, clouds produce dramatic sunbeams known as **CREPUSCULAR RAYS.** To do so, they need the help of a hazy atmosphere. The haze catches the sunlight to reveal where beams of light shine through gaps in the clouds. These rays spread out in a fan when the Sun is low and so its light is shining toward or away from you.

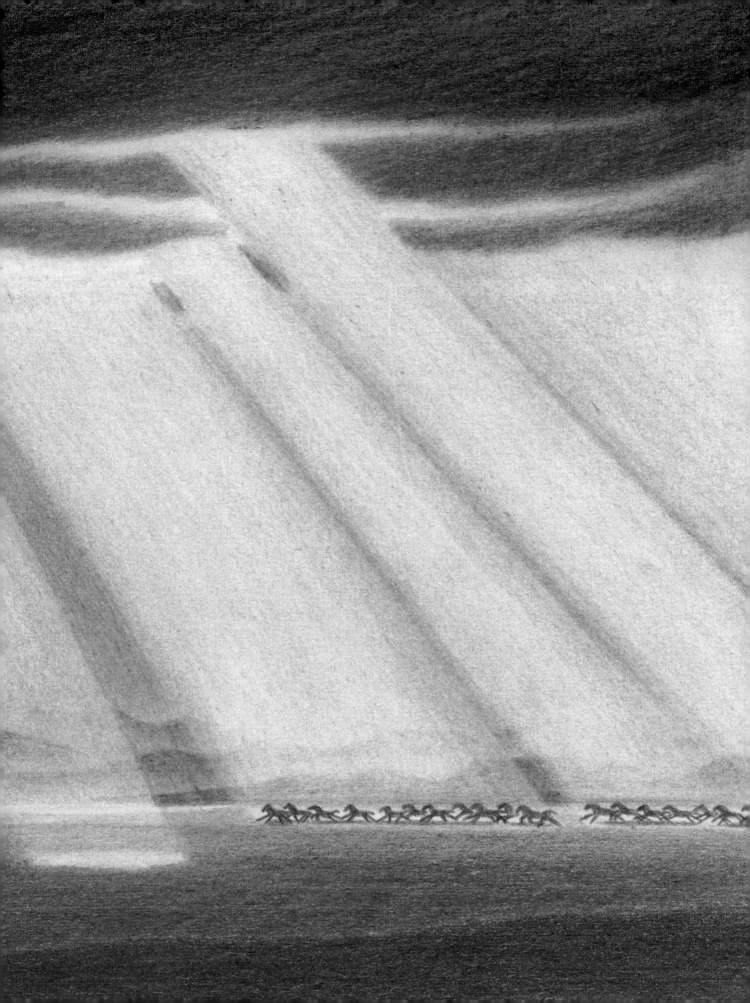

Does your cloud have big dreams of making its mark beyond Earth? Does it yearn to become one of the **EXTREME-ALTITUDE CLOUDS** or even the **EXTRATERRESTRIAL CLOUDS?**

There's nothing wrong with dreaming. Especially when you're a cloud.

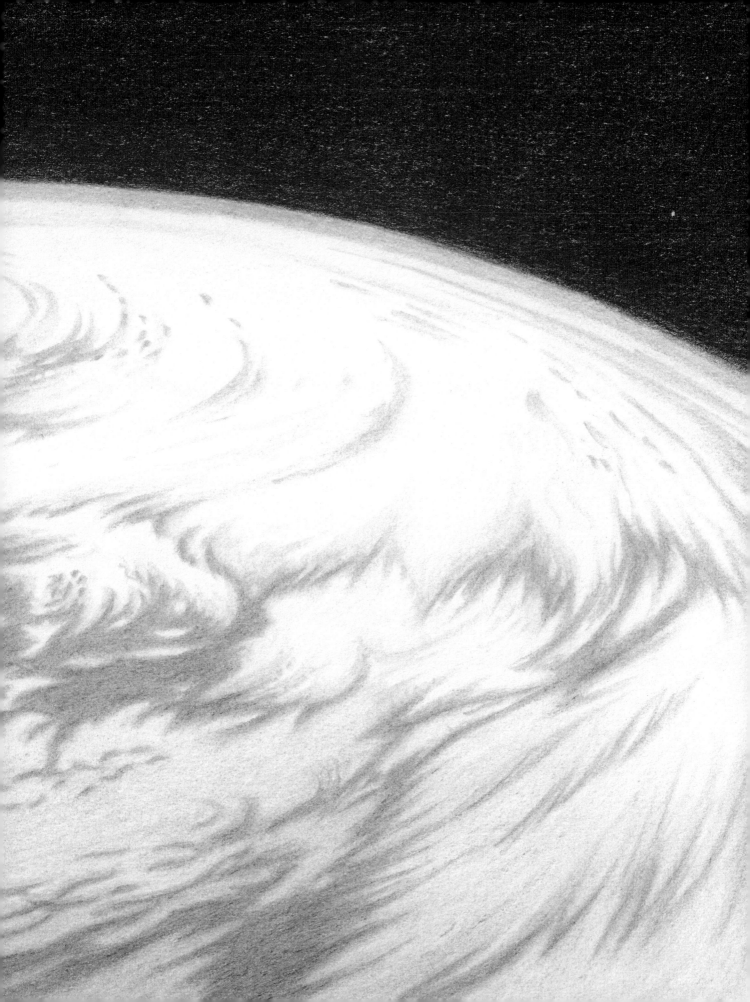

Super-high Clouds

THERMOSPHERE

440

MILES

Meteor

Aurora

50

MESOSPHERE

Sounding
rocket

30

STRATOSPHERE

Fighter jet

Weather balloon

OZONE LAYER

7

TROPOSPHERE

Himalayas

Cumulonimbus

0

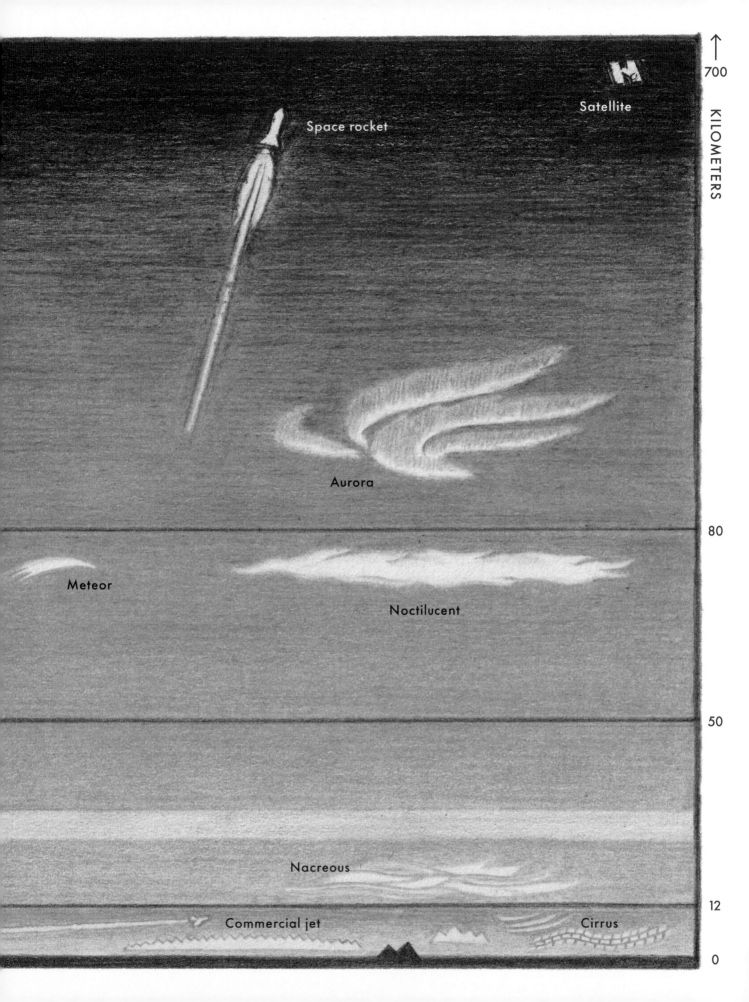

At fifty miles up, **NOCTILUCENT** clouds are the highest clouds in our atmosphere. You can see them only in the summer months, at night, when they look like blueish, ghostly ripples against a starry sky. Their ice crystals are so high they catch the sunlight when the atmosphere below is dark.

NACREOUS clouds form at altitudes of about ten to fifteen miles, and they can show bright iridescent colors as the sunlight shines through them at the start or end of the day. Like noctilucent, they form towards the poles, but these clouds appear in the middle of winter.

Looking down on clouds from space reveals massive patterns we can't see from the ground. Only from up here can you see Cumulonimbus storm clouds join forces and coordinate into swirling **STORM SYSTEMS** that grow into cyclones and hurricanes.

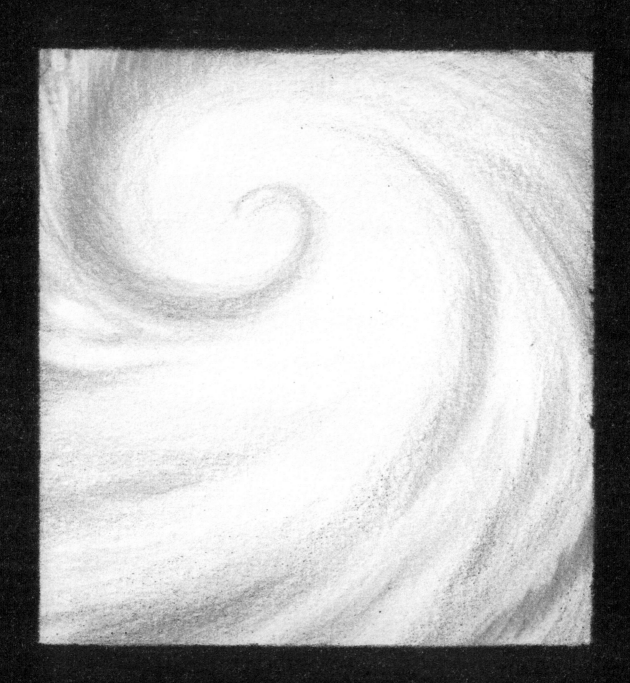

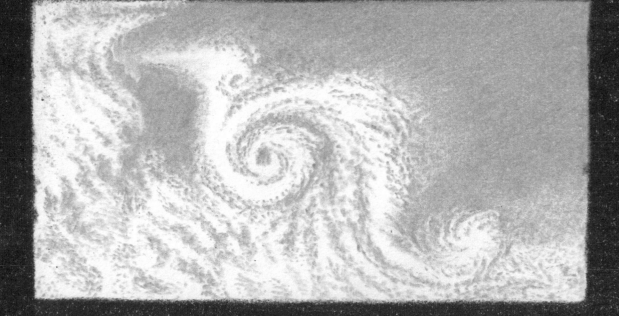

As ocean winds flow over islands with mountains, they swirl in huge eddies that can shape the clouds into spirals known as **VON KÁRMÁN VORTEX** clouds. Sometimes more than a hundred miles long, they're too big to notice from a boat on the water.

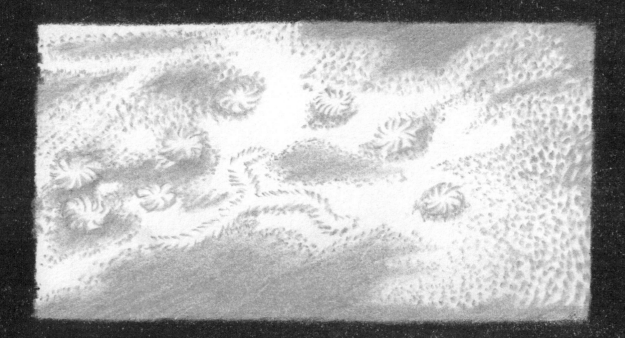

Another cloud pattern too large to be spotted from below was first discovered when early satellite photos in the 1960s showed clouds in enormous star shapes. These became known as ACTINOFORM clouds. What makes the patterns appear is still a mystery.

MERCURY the closest planet to our Sun, doesn't have an atmosphere. No atmosphere, no clouds. Simple as that.

VENUS has a dense atmosphere that traps the Sun's heat, making its surface the hottest of all the planets. It is covered in thick yellow clouds formed from droplets of sulphuric acid. Nice.

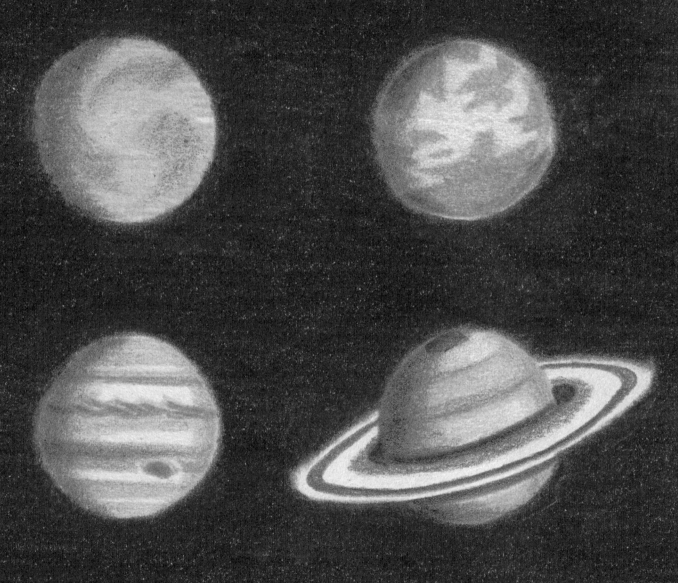

JUPITER has clouds of ammonia ice crystals, with water ice clouds beneath them. These sweep around the planet in bands that swirl with massive storms.

SATURN has cloud bands rather like Jupiter's. The clouds around its north pole form the shape of a huge hexagon. Why? Nobody knows.

EARTH is the only planet we know where water changes easily between the invisible gas called water vapour and the water droplets or ice crystals we see as clouds. That is why it has the perfect mix of clouds and clear skies.

MARS has an atmosphere that is much thinner than Earth's. Its few clouds resemble our Cirrus clouds. While some are probably made of frozen water, like ours, others are probably frozen carbon dioxide.

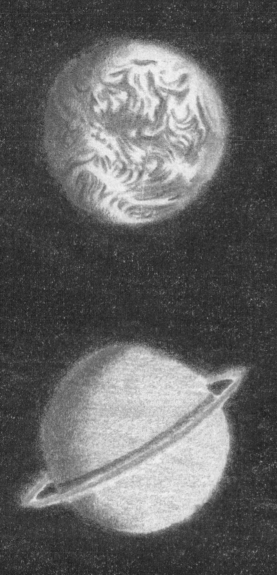

URANUS is covered in a pale turquoise hazy fog. Its lower clouds are likely made of water ice; its higher ones, crystals of frozen methane.

NEPTUNE, farthest planet from the Sun, has streaks of white clouds that seem to change as the Sun becomes more or less active. Neptune's clouds are currently fading away, and we have no idea why.

Where would we be without **EARTH'S CLOUDS**?

They purify our water, turning salty oceans into fresh lakes and rivers. They clean our atmosphere, bringing its dust down in rain. They cool the planet, reflecting away more heat than they trap in. And they ensure that every morning, when you open your curtains, the sky is a new page to read.

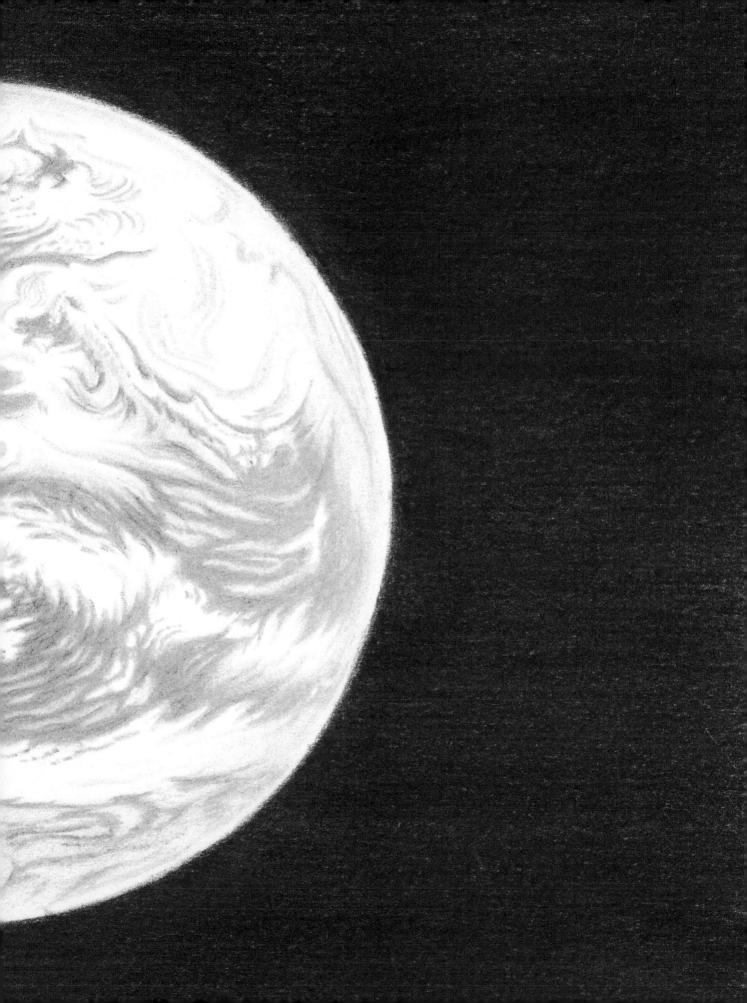

Whatever your cloud grew up to be, it'll likely
be disappearing now because no cloud lasts
forever. But nor do clouds ever really die.
Their droplets or crystals just change back
into the gas form of water we can't see.

One thing's certain: The sky is always changing.
And so your cloud will be back. But it will look
different next time, because every cloud is unique.

So, if you spot something special in the clouds,
pay attention. Don't miss it, because no other
cloud will ever be quite the same – you might be
the only person in the world who chose to spot it.

A Cloudspotter's Glossary

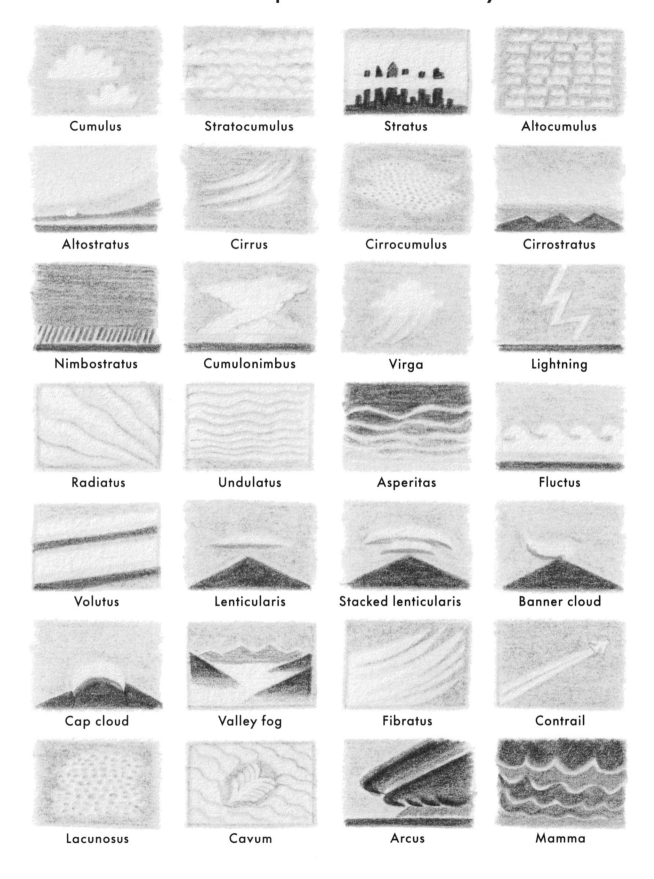

Cumulus

Stratocumulus

Stratus

Altocumulus

Altostratus

Cirrus

Cirrocumulus

Cirrostratus

Nimbostratus

Cumulonimbus

Virga

Lightning

Radiatus

Undulatus

Asperitas

Fluctus

Volutus

Lenticularis

Stacked lenticularis

Banner cloud

Cap cloud

Valley fog

Fibratus

Contrail

Lacunosus

Cavum

Arcus

Mamma

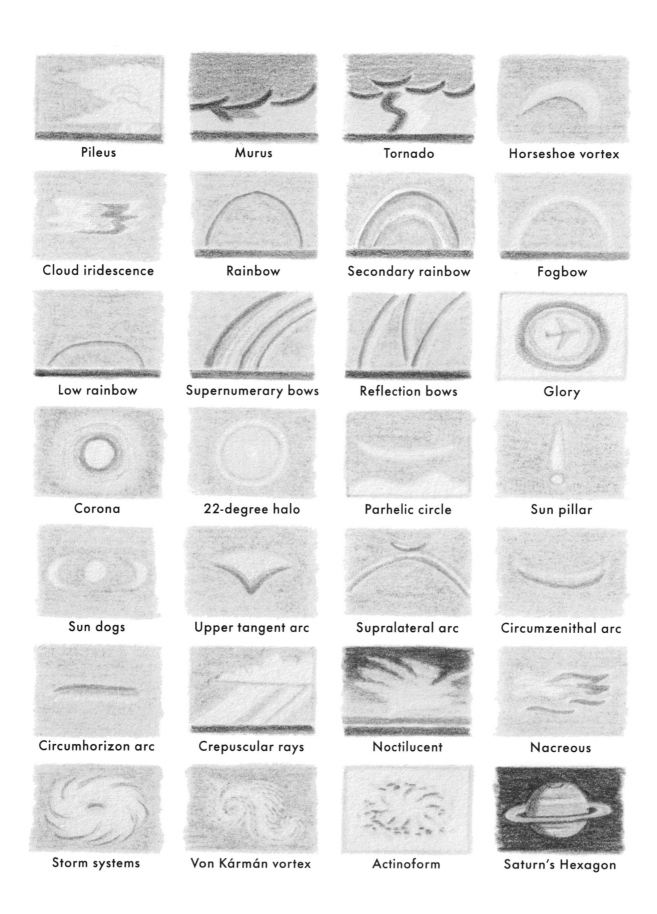

Pileus Murus Tornado Horseshoe vortex

Cloud iridescence Rainbow Secondary rainbow Fogbow

Low rainbow Supernumerary bows Reflection bows Glory

Corona 22-degree halo Parhelic circle Sun pillar

Sun dogs Upper tangent arc Supralateral arc Circumzenithal arc

Circumhorizon arc Crepuscular rays Noctilucent Nacreous

Storm systems Von Kármán vortex Actinoform Saturn's Hexagon

For Flora and Verity | Gavin Pretor-Pinney

For Penny | William Grill

Our thanks to Richard Atkinson, Sam Fulton, Matthew Watson Young, Imogen Scott, Peter Pawsey, Matthew Hutchinson, Violet Zhang, and Neil Dunnicliffe, as well as to Professor Giles Harrison (Meteorology, University of Reading) for checking and correcting our cloud science.

Published in the United States by Ten Speed Press, an imprint of the Crown Publishing Group, a division of Penguin Random House LLC, New York. TenSpeed.com

Ten Speed Press and the Ten Speed Press colophon are registered trademarks of Penguin Random House LLC.

Originally published in hardcover in Great Britain by Particular Books, an imprint of Penguin Random House UK, in 2024.

Library of Congress Cataloging-in-Publication Data is on file with the publisher.

Hardcover ISBN: 978-0-593-83605-7
eBook ISBN: 978-0-593-83606-4

Printed in China

Editor: Kimmy Tejasindhu
Production editor: Serena Wang
Design manager: Isabelle Gioffredi
Production manager: Serena Sigona
Copyeditor: Mark McCauslin
Marketer: Joey Lozada

10 9 8 7 6 5 4 3 2 1

First US Edition